The poetry of
Parmigianino's
schiava Turca

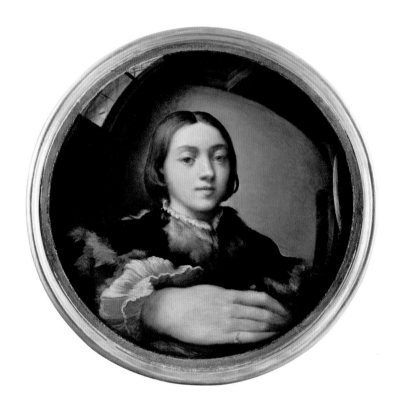

Parmigianino

1503–1540

Self-Portrait in a Convex Mirror, ca. 1524

The poetry of Parmigianino's Schiava Turca

AIMEE NG

WITH A FOREWORD BY
DAVID EKSERDJIAN

THE FRICK COLLECTION, NEW YORK

This catalogue is published in conjunction with the exhibition *The Poetry of Parmigianino's "Schiava Turca,"* organized by The Frick Collection with the Foundation for Italian Art & Culture. The guest curator is Aimee Ng. Support for the presentation in New York is generously provided by Gabelli Funds, Aso O. Tavitian, The Gladys Krieble Delmas Foundation, Mr. and Mrs. Hubert L. Goldschmidt, Hester Diamond, and the Foundation for Italian Art & Culture.

The presentation in San Francisco is made possible by a lead sponsorship from the Frances K. and Charles D. Field Foundation, in memory of Mr. and Mrs. Charles D. Field.

The Frick Collection, New York
May 13–July 20, 2014

Legion of Honor
Fine Arts Museums of San Francisco
July 26–October 5, 2014

Published by The Frick Collection,
1 East 70th Street, New York, NY 10021
www.frick.org

Michaelyn Mitchell, Editor in Chief
Hilary Becker, Assistant Editor

Designed by Luke Hayman and
Aaron Garza, Pentagram
Typeset in Monotype Centaur and Ludovico
Printed in China

Front cover: Parmigianino, *Schiava Turca,* detail

Frontispiece: Parmigianino, *Self-Portrait in a Convex Mirror,* ca. 1524. Oil on panel, 24.4 cm diam. Kunsthistorisches Museum, Vienna

Page 11: Parmigianino, *Schiava Turca,* ca. 1531–34. Oil on panel, 68 x 53 cm. Galleria Nazionale di Parma

Back cover: Parmigianino, *Schiava Turca,* detail of ornament on headdress

First printing

Library of Congress Cataloging-in-Publication Data

Ng, Aimee.
 The poetry of Parmigianino's Schiava turca / Aimee Ng ; with a foreword by David Ekserdjian.
 p. cm.
 Published in conjunction with an exhibition held at The Frick Collection, New York, May 13–July 20, 2014, and at the Fine Arts Museums of San Francisco, July 26–Oct. 5, 2014.
 Includes bibliographical references and index.
 ISBN 978-0-912114-60-6
1. Parmigianino, 1503-1540. Turkish slave--Exhibitions. I. Parmigianino, 1503-1540. II. Frick Collection. III. Fine Arts Museums of San Francisco. IV. Title.
 ND623.P255A76 2014
 759.5--dc23

2013048748

CONTENTS

FOREWORD

Thirty-seven is a potentially dangerous age for great artists. Raphael (1483–1520) was thirty-seven when he died, and so—exactly twenty years later—was Francesco Mazzola, better known as Parmigianino (1503–1540). Whether because of this spooky coincidence or for other reasons, Parmigianino was already seen as Raphael reborn at an early date: in Vasari's *Life* of the artist, he claims that the youthful Francesco Mazzola was hailed in these terms on his arrival in Rome as a precociously gifted twenty-one-year-old. Happily for posterity, his *Self-Portrait in a Convex Mirror*, which made his name, remains as a haunting record of his appearance at that time.

Parmigianino may not be as celebrated an artist as Raphael, but he is unquestionably a major figure. His gifts were many-faceted, with the result that it is not just as a painter, but also as a prolific draftsman and pioneering printmaker that he is revered. Nevertheless, nobody familiar with the full range of his output would deny that his painted portraits occupy a place of particular honor within his work.

The vast majority of Parmigianino's portraits are of men, with a mere four being of women. Of these, the so-called *Antea*, shown at The Frick Collection in 2008, and the so-called *Schiava Turca*, the heroine of the present exhibition, are unquestionably the most compelling.

The immediate visual appeal of the *Schiava Turca* is plain for all to see, but the directness of her gaze does not mean that she is without mystery. On the contrary, almost the only things we can be sure about are that she is neither a slave girl nor Turkish.

In the essay that follows, Aimee Ng explores the complexities of this haunting image with remarkable subtlety and attention to detail. She connects the *Schiava Turca* with three drawings of young women—all conceivably of the same young woman—by Parmigianino, one of which was first published as his work as recently as 2011. She also speculates about the possible associations between this likeness, which shows the sitter wearing a turban-like headdress adorned with the device of a winged horse, and a mythological painting by the artist, in which another—or the same?—winged horse is accompanied by a nude female figure and Cupid.

Hers is a poetic reading, and she argues that the sitter in the portrait was a female poet. Better yet, she offers a fascinating suggestion concerning her identity. Like so many of the most rewarding hypotheses in the history of art, it is bound to be controversial, at least to begin with, but even any skeptics will surely agree that it has made them think more deeply and look more closely at this stupendous painting.

David Ekserdjian

The Foundation for Italian Art & Culture (FIAC) is delighted to partner with The Frick Collection and the Fine Arts Museums of San Francisco on the presentation of Parmigianino's masterpiece *Schiava Turca*, which is on loan from the Galleria Nazionale di Parma.

An exquisite portrait of a young woman wearing a turban-like headdress, the *Schiava Turca* captivates her audience with lush textures and mysteriously elongated, yet beautiful features that are emblematic of Parmigianino's Mannerist paintings. The painting's historic visit to the Frick follows another iconic Parmigianino painting, *Antea*, which was brought from the Museo di Capodimonte in Naples in 2008. The presentation of the *Schiava Turca* marks FIAC's third project with the Frick. Our first collaboration, in 2004, featured Raphael's *La Fornarina*.

We are very enthusiastic to also be sharing this momentous event with the Fine Arts Museums of San Francisco, with whom we are partnering for the first time. By showcasing this portrait on both coasts, the exhibition exemplifies FIAC's ideal project and further realizes its mission to promote outstanding Italian art throughout the United States. These prestigious partnerships signify an important achievement for FIAC.

Along with our distinguished board members, we wish to express our sincerest thanks to Dr. Mariella Utili, Director of the Galleria Nazionale di Parma, and her staff for their remarkable cooperation. Our deepest appreciation also goes to Colin B. Bailey, former Deputy Director and Peter Jay Sharp Chief Curator at The Frick Collection and now Director of Museums at the Fine Arts Museums of San Francisco, and to Ian Wardropper, Director of the Frick, and his staff for their ongoing support and collaboration.

We are certain that this enriching and noteworthy exhibition will pave the way for future opportunities to bring Italian masterpieces to American audiences.

Daniele D. Bodini
Chairman, Foundation for
Italian Art & Culture

Alain Elkann
President, Foundation for
Italian Art & Culture

ACKNOWLEDGMENTS

It has been a pleasure for our respective museums to work together to bring Parmigianino's exquisite portrait *Schiava Turca* to audiences in New York and San Francisco. On loan from the Galleria Nazionale di Parma and in the United States for the first time, this masterpiece epitomizes the contribution to portraiture of one of the greatest painters of his age. At the Frick, its presentation continues a wonderful series on the female portrait in the Renaissance, which has been organized in collaboration with the Foundation for Italian Art & Culture. Special thanks go to the Galleria Nazionale di Parma, in particular Mariella Utili, Director, for lending this portrait, and to Ambassador Daniele D. Bodini, Chairman, and Alain Elkann, President, at the Foundation for Italian Art & Culture, for facilitating the loan. In New York, heartfelt thanks go to Gabelli Funds, Aso O. Tavitian, The Gladys Krieble Delmas Foundation, Mr. and Mrs. Hubert L. Goldschmidt, Hester Diamond, and the Foundation for Italian Art & Culture for their generous financial support of the project. The presentation at the Legion of Honor is made possible by a lead sponsorship from the Frances K. and Charles D. Field Foundation, in memory of Mr. and Mrs. Charles D. Field, for which the Fine Arts Museums are most grateful.

Guest Curator Aimee Ng, Research Associate at the Frick and Lecturer in the Department of Art History and Archaeology at Columbia University, has brought a fresh and astute perspective to her interpretation of the portrait, providing a compelling case for the *Schiava Turca* being the portrait of a poet. We are very grateful to her and also to David Ekserdjian, Professor of History of Art and Film at the University of Leicester and a noted Parmigianino authority, for contributing the foreword.

We also wish to acknowledge the exceptional work of those on our respective staffs, especially Denise Allen at the Frick. Others at the Frick whose contributions deserve recognition include Rosayn Anderson, Adrian Anderson, Hilary Becker, Michael Bodycomb, Rika Burnham, Tia Chapman, Julia Day, Diane Farynyk, Anna Finley, Susan Galassi, Allison Galea, Joseph Godla, Robert Goldsmith, Adrienne Lei, Alexis Light, Allison Lonshein, Patrick King, Michaelyn Mitchell, Olivia Powell, Heidi Rosenau, Xavier F. Salomon, Katie Steiner, and Nick Wise, as well as Stephen Saitas and Anita Jorgensen. At the Fine Arts Museums, we acknowledge Richard Benefield, Krista Brugnara, Melissa Buron, Michele Gutierrez-Canepa, Therese Chen, Elise Effmann Clifford, Julian Cox, Leslie Dutcher, Craig Harris, Bill Huggins, Maureen Keefe, Patty Lacson, Daniel Meza, Lisa Podos, and Sheila Pressley.

<div style="text-align:center">

Ian Wardropper
Director
The Frick Collection

Colin B. Bailey
Director of Museums
Fine Arts Museums of San Francisco

</div>

ACKNOWLEDGMENTS

It gives me great pleasure to extend my sincere gratitude to the many people who have made possible the research and writing of this catalogue and the exhibition it accompanies. First and foremost, my thanks go to Ian Wardropper, Director of the Frick, for his steadfast support, and to Colin B. Bailey, Director of Museums at the Fine Arts Museums of San Francisco and former Deputy Director and Peter Jay Sharp Chief Curator at the Frick, for entrusting me with this wonderful project. I am also indebted to my warm and generous colleagues at the Galleria Nazionale di Parma, above all, Mariella Utili, who has so graciously allowed the *Schiava Turca* to travel to the United States for this exhibition. I want to acknowledge Ines Agostinelli, Valentina Catalucci, Annarita Ziveri, and especially Lorenzo Sbaraglio, whose passion for the city of Parma and its art is inspiring. I am grateful to many esteemed colleagues and friends who have shared their expertise with me, including Carmen Bambach, Eveline Baseggio Omiccioli, Andrea Bayer, Lina Bolzoni, Jane Bridgeman, Christina Ferando, Jessica Maratsos, Zoë Tan, Mary Vaccaro, and Colin Webster. Very special thanks go to David Ekserdjian, who offered invaluable comments on my essay and composed the eloquent foreword.

It is difficult to sufficiently express my appreciation to my colleagues at The Frick Collection and the Frick Art Reference Library. Particular thanks go to Rosayn Anderson, Hilary Becker, Michael Bodycomb, Diane Farynyk, Susan Galassi, Joseph Godla, Robert Goldsmith, Serena Rattazzi, Xavier F. Salomon, and Katie Steiner. I thank Michaelyn Mitchell for her patient editorial guidance and scrupulous refinement of my prose and for working with Luke Hayman and Aaron Garza to produce this catalogue, whose beauty echoes that of the painting it celebrates. My heartfelt thanks go to Nick Wise, with whom many ideas came into being during late evening discussions at the Frick. Finally, I am but one of many who have had the privilege of Denise Allen's mentorship and passionate dedication to the German concept of Nachwuchswissenschaftler, by which so-called "emerging scholars" come into their own through the support and guidance of mentors who both push them forward and lead the way. For this and so much else, I am deeply indebted to Denise, who, by example, teaches an art history that respects the object above all in contributions that are witty, beautiful, and poetic.

Aimee Ng

THE POETRY
OF PARMIGIANINO'S
Schiava Turca

BY AIMEE NG

\mathcal{F}rom a young age, Francesco Mazzola (1503–1540), called Parmigianino, gained access to the highest ranks of society through his talent. By the time he was twenty-one, he had presented his art to Pope Clement VII; soon after, he painted for Emperor Charles V. Throughout his short life, he was patronized by members of the refined courts of Northern Italy, as well as by powerful cultural figures like the great writer Pietro Aretino (1492–1556).[1] He mastered every medium and format associated with painting, but he reserved portraiture as a special means of showcasing his inventive talents. It was, after all, with his *Self-Portrait in a Convex Mirror* (frontispiece) that Parmigianino introduced himself, his wit, and his unique painterly style to Pope Clement

1 For paintings presented to Clement, Charles, and Aretino, see Vasari 1966–87, vol. 4, 535–36, 539–41. See also Ekserdjian 2006, 6 and 9.

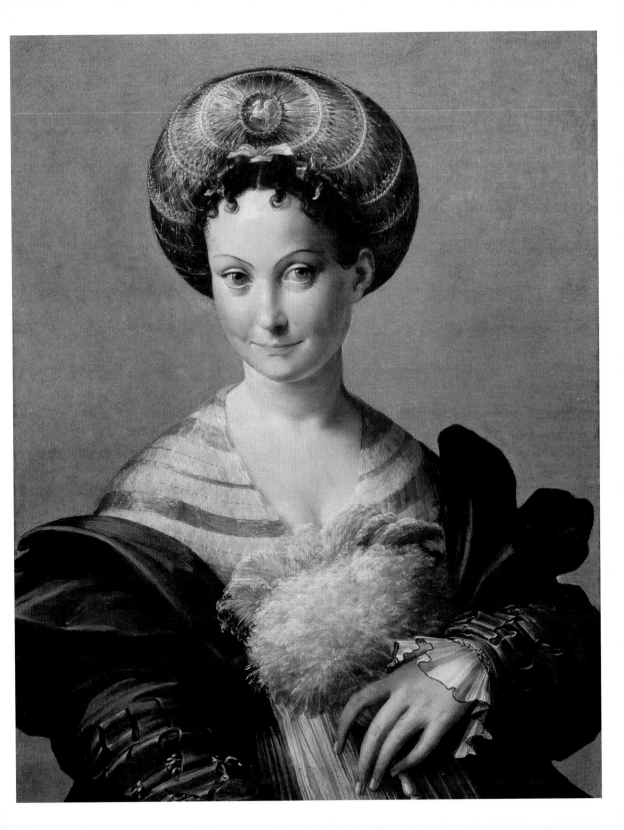

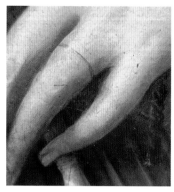

and with his painting, from memory, of a portrait of Charles V that he impressed the emperor.[2] Parmigianino's technical mastery and intense creativity coalesce in his portraits, a genre whose strict conventions he experimented with and sometimes delightfully subverted. Today, his exquisite *Schiava Turca* (page 11)—one of only four surviving portraits of women by the artist—is an icon of Parma, the painter's city of birth and the source of his popular name.[3]

The *Schiava Turca*'s remarkable, almost theatrical, costume characterizes the picture as much as her arresting face. Her ball-shaped headdress, or *balzo*, a mark of the highest fashion among women of the Northern Italian courts, is lavishly decorated with a striking gold emblem of a white winged horse.[4] A luxurious striped partlet (a garment typically covering the neck and upper chest), made of a silk weave, exposes the tops of her rounded breasts while a dress of deep blue satin with drooping, voluminous, slashed sleeves accentuates the slope of her shoulders. A white ruffle embellished with black embroidery flares at her wrist, and a blue drawstring, perhaps meant to cinch the sleeve, dangles loosely below. A white apron—an accessory of fashion rather than of domesticity—falls from her waist. Her costume may reflect a local fashion as the combination of the apron, voluminous sleeves, and collarless V-neck partlet is not commonly seen in female portraits of the period.[5] She lightly presses the turned ivory handle of her fan against her body, and the downy ostrich feathers draw attention to her décolletage. Her extravagant costume contrasts with an almost complete absence of jewelry: all that can be seen is an extremely thin gold band on the ring finger of her left hand, which was believed to connect most directly to the heart (FIG. 1). She could be standing or sitting although the latter is more likely. She turns her body to the right and directs her face to

2 Vaccaro 2002, nos. 40 and C3. The catalogue entries of Vaccaro 2002 will be cited frequently for illustrations and literature for works discussed in the text; Ekserdjian 2006 presents a fuller and more recent account of some works and is cited when appropriate.

3 By contrast, at least seventeen portraits of men have been attributed to Parmigianino. See the *Schiava Turca* literature on page 44 of this volume.

4 On the *balzo*, which was popular in the fifteenth century and revived in the sixteenth, see Gnignera 2010, 15–33, and Levi-Pisetzky 1966,

vol. 3, 90–93. On the *balzo* as an accessory particular to Isabella d'Este and her circle, see Goretti 2009, 53 n. 8.

5 I thank Jane Bridgeman for discussing the *Schiava Turca*'s costume with me.

the left, revealing the delicate contour of her left ear. As she smiles, her eyes confront the viewer with a playful look. Her pose is active, her costume ostentatious, her expression frank; yet she retains her mystery.

As in so many portraits of Renaissance women, the identity of the woman called the *Schiava Turca* is unknown. Some modern scholars have suggested that she is not an actual person but rather a feminine ideal created for male delectation.[6] The actual and the ideal, however, need not be mutually exclusive. In Renaissance portraits, it was common practice to conform a female sitter's features to the most perfect standards of beauty.[7] While the *Schiava Turca*'s face is certainly idealized, it retains a strong sense of individuality. The way she looks out at the viewer—so engaged, direct, and present—suggests not only that she is an actual person but also that she might be someone the artist knew.[8] She is beautiful, idealized, and delectable, but she is not generic.

If the *Schiava Turca*'s identity was once known, it was swiftly forgotten. In 1675, the painting, then in the collection of Cardinal Leopoldo de' Medici in Florence, was described as a "portrait of a young woman with a turban, without jewelry, holding a white fan in her left hand."[9] The 1561 inventory of Francesco Baiardo, the patron and friend of Parmigianino and great early collector of his art, lists a portrait of an unnamed woman that may have been the *Schiava Turca*.[10] If so, the subject's name had already been lost some thirty years after Parmigianino painted her. The portrait's misleading title, *Schiava Turca* (Turkish slave), was coined in 1704 by a cataloguer at the Uffizi Gallery who likely mistook her *balzo* for a turban, identified the ostrich-feather fan with the exotic east, and interpreted the gold chain in her right sleeve as a reference to captivity.[11] While the capricious title probably has nothing to do with the sitter's identity, it draws attention to her theatricality and fantastical appeal.

6 See, for example, Ekserdjian 2006, 150.

7 See "Beauty and Identity in Parmigianino's Portraits," in Vaccaro 2002, 32–38.

8 Vaccaro 2002, 204, also notes the sense of familiarity.

9 "Ritratto di donna giovane con turbante in capo, senza vezzo, con la sinistra tiene un pennacchio bianco, di mano di Parmigiano." See Vaccaro 2002, 204. Translations are mine unless otherwise noted.

10 The Baiardo inventory dated 30 September 1561 is transcribed in Popham 1971, vol. 1, 264: "No. 19, un ritratto di una donna sin'a mezzo colorito finito alto o 16 largo o 12 di mano del Parmesanino." On the dimensions, see Ekserdjian 2006, 160.

11 "Con 'quadro in tavola alto B.1 1/6 largo P.18 dipintovi di mano de Parmigianino mezza figura il ritratto di una schiava turcha con turbante in testa; e rosta in mano di penne bianche." Transcribed in Vaccaro 2002, 205 n. 2.

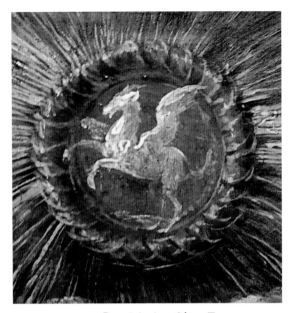

FIG. 2. Parmigianino, *Schiava Turca*,
detail of ornament on headdress

Thus far, no proposed identity for this mysterious woman has been convincing. One recent suggestion, which takes the designation "Turkish slave" seriously, posits that the sitter is the noblewoman Giulia Gonzaga, portrayed on the occasion of her marriage to Vespasiano Colonna. Giulia was threatened with abduction by a Turkish invader and actually risked becoming a "Turkish slave."[12] As a betrothal portrait of Giulia, the painting thus would have commemorated her exotic, happily unconsummated adventure. Other less romantic proposals identify the winged horse on the headdress (FIG. 2) as the key that unlocks the sitter's identity. Scholars have interpreted it as a heraldic emblem, proposing that the sitter is a member of the Baiardo family, whose coat of arms includes a horse's head, or perhaps a member of the Cavalli family, whose arms include a horse.[13] But the strict language of heraldry does not allow for a winged steed to substitute for an earthly horse. The *Schiava Turca*'s horse must be a mythological creature, likely Pegasus, the winged horse that sprang full-grown from the blood dripping from Medusa's severed head.

In Renaissance Italy, Pegasus was the quintessential emblem of humanist poetry. Classical myths tell of how Pegasus struck the ground on Mount Helicon with his hoof and from the riven earth drew forth the Hippocrene spring, the font of poetic inspiration that was sacred to Apollo and the Muses.[14] Pietro Bembo (1470–1547), one of the most significant poets of Parmigianino's time, adopted the imagery of Pegasus striking the earth and drawing forth the stream as his personal device (FIG. 3).[15]

12 De Rossi 2007. This proposal, however, would mean that Parmigianino painted the portrait before 1528 (when Giulia was widowed), which does not accord with its dating, discussed below, to the early to mid-1530s. Moreover, the name "Turkish slave" was not coined until centuries later.

13 For the Baiardo family, see Ekserdjian 2006, 160. For the Cavalli family, see Tentolini 1952, 22, and Chiusa 2001, 96–97.

14 Ovid, *Metamorphoses*, V: 256ff.

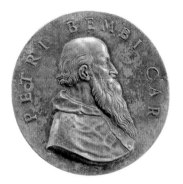

The winged horse and the stream on the *Schiava Turca*'s ornament associate her with this poetic context, as scholars have rightly noted, but the precise nature of her relationship to contemporary poets, to poetry, and to painting has yet to be clarified.[16]

Portraits of women in the Renaissance were often conceived of in the Petrarchan tradition in which the humanist poet Petrarch (1304–1374) and the Sienese painter Simone Martini (ca. 1284–1344) competed over which of them could best capture and convey the beauty of Petrarch's muse, Laura. This Renaissance incarnation of the classical concept of *ut pictura poesis*—"as is painting, so is poetry"—lay at the heart of Renaissance portraiture, and Parmigianino's immersion in the *paragone* (comparison or competition) between painting and poetry is well known.[17] Whether in religious and mythological pictures or in portraits, his beautiful women contend directly with the ideals of feminine beauty expressed in Renaissance poems. This theme is eloquently documented in a Parmigianino sheet in the Tobey Collection, in which the head of a woman is rendered multiple times next to excerpts from a poem by Petrarch (FIG. 4).[18]

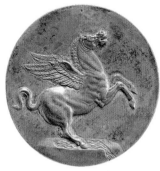

FIG. 3. Danese Cattaneo, *Portrait Medal of Pietro Bembo with Pegasus on Reverse*, 1547–48. Bronze, 5.6 cm diam. Museo Nazionale del Bargello, Florence

Parmigianino celebrates not only the beauty of his subject but also his own ability to capture, perfect, and immortalize it with his art; in so doing, he challenges the power of the poet's written word. Seen in this light, the *Schiava Turca* is very much like

15 The medal, once attributed to Benvenuto Cellini and now given to Danese Cattaneo, presents Bembo as a cardinal and thus must be dated after 1539, when he received his cardinalate. Beltramini 2013, no. 6.13 (entry by Davide Gasparotto), dates the example in the Bargello, Florence (inv. no. 6207), to 1547–48.

16 For example, on the *Schiava Turca* in the context of poetry from Parma, see Ceruti Burgio 1999.

17 On Horace's "Ut pictura poesis" and studies of portraiture and painting, see Bolzoni 2008 and Cranston 2000. On Parmigianino and poetry, see Cropper 1976.

18 Wolk-Simon and Bambach 2010, no. 13. Inscriptions include "a amor quando fioriva" from Petrarch's poem number 325 in the *Rime Sparse*.

other Renaissance portraits of women, but it is also unlike them in several ways. Her twisting pose—with her body facing right and her head turned left—is a common feature not of portraits of women but of men, such as Parmigianino's *Malatesta Baglione* (Kunsthistorisches Museum, Vienna) and *Portrait of a Man* (FIG. 5).[19] In contrast, the other three women Parmigianino painted (*Antea; Portrait of Camilla Gonzaga, Countess of San Secondo, and Three Sons;* and *Portrait of Countess Gozzadini;* FIGS. 6–8) maintain static poses in which their bodies face in the same direction as their faces. Stillness was the convention for portraits of Renaissance women. The torsion of Leonardo's *Lady with an Ermine* (see FIG. 17) was an extraordinary innovation, and the painting is heralded as the "first modern portrait" for this very reason.[20]

The circular ornament on the *Schiava Turca*'s *balzo* (see FIG. 2)—a white enameled relief of Pegasus drawing forth the Hippocrene spring, perhaps in repoussé, raised from a gold concave background—also departs from the conventions of female portraiture. The *balzo* itself is a strictly feminine accessory usually embellished with a woven abstract design or set with a jewel at its center, as is seen, for example, in Parmigianino's *Portrait of Countess Gozzadini* and Titian's *Portrait of Isabella d'Este* (see FIG. 19). In the *Schiava Turca,* however, the object type and its imagery seem to identify the ornament as an accessory typically reserved for men. It appears to be an *enseigne*, or hat badge.[21] These were derived from military badges, which were made to bear the personal emblems of the men who wore them. Parmigianino's male sitters are occasionally shown with hat badges. In his portrait of Galeazzo Sanvitale, Lord of Fontanellato (FIG. 9), for example, Sanvitale wears a badge depicting the twin columns of Hercules, signifying his virtues as a ruler.[22] In the *Schiava Turca,* Parmigianino adopts this distinctly male accessory to decorate his sitter's fashionable, feminine headdress. Scholars have also noted that her expression is unusual in the context of female portraiture of the time.[23] Her frank, smiling gaze is unlike the

19 For the so-called *Malatesta Baglione,* see Vaccaro 2002, no. 54, and Ekserdjian 2006, 154–56. For *Portrait of a Man,* see Ekserdjian 2006, 144, where it is published for the first time.

20 Syson 2011, no. 10.

21 Hackenbroch 1996 and Leino 2013, 189–203. Ferino-Pagden and Fornari Schianchi 2003, no. II.2.28, identifies the ornament on the *balzo* as an *enseigne.* To my knowledge, the only other example of a woman wearing this kind of emblematic badge is Paris Bordon's *Portrait of a Woman and a Boy* in the Hermitage, St. Petersburg. See Fomichova 1992, no. 69.

22 For *Portrait of Galeazzo Sanvitale,* see Vaccaro 2002, no. 41.

23 For example, Vaccaro 2002, 204, who describes it as "lively and intelligent."

24 For *Cupid Carving His Bow,* see Vaccaro 2002, no. 34. Fornari Schianchi 1998, no. 163 (entry by Anna Coliva), also points out the connection to *Cupid Carving His Bow.*

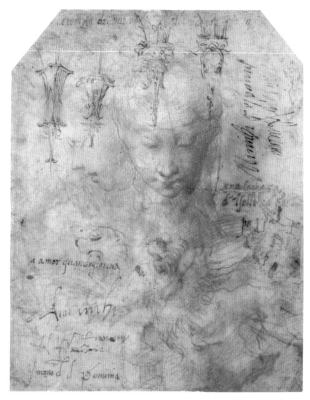

FIG. 4. Parmigianino, *Studies of a Female Head, a Winged Lion, and Finials,* ca. 1522–24. Red chalk and pen and brown ink, 18.5 x 14.5 cm. The Tobey Collection, Promised gift of David M. Tobey to The Metropolitan Museum of Art

impassive faces of Parmigianino's other female sitters: it is more akin to that of the god of love in the artist's *Cupid Carving His Bow* (FIG. 10) than to that of a decorous Northern Italian woman.[24]

The *Schiava Turca* defies a number of conventions of female portraiture. The sitter looks out at the viewer with a direct expression, adopting a pose typically used for men and wearing an accessory borrowed from male fashion. She is beautiful, but she is not a passive beauty. Rather than a silent muse who inspires men to express their poetic potential, she appropriates the conventions of the masculine—of the poet—for herself. Instead of being the subject of poetic dedication, she may, herself, be a poet. After all, she wears upon her head—the seat of creativity—a badge of Pegasus striking forth the Hippocrene spring, the source of poetic inspiration.

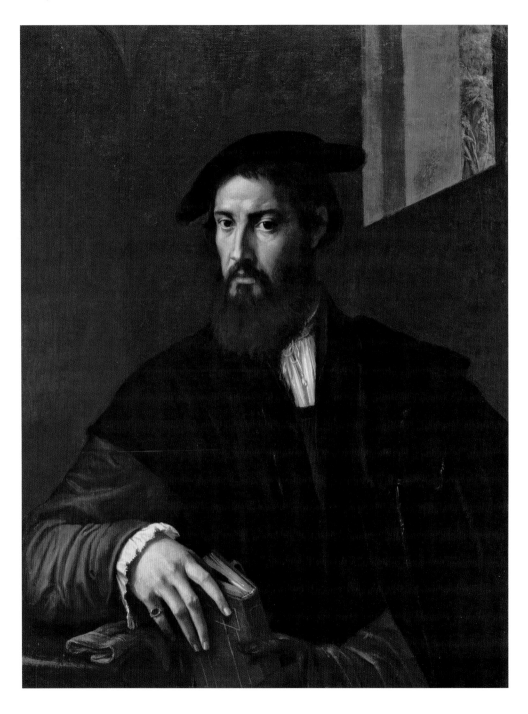

FIG. 5. Parmigianino, *Portrait of a Man*, ca. 1527–31. Oil on canvas, 88.9 x 68 cm. Private collection

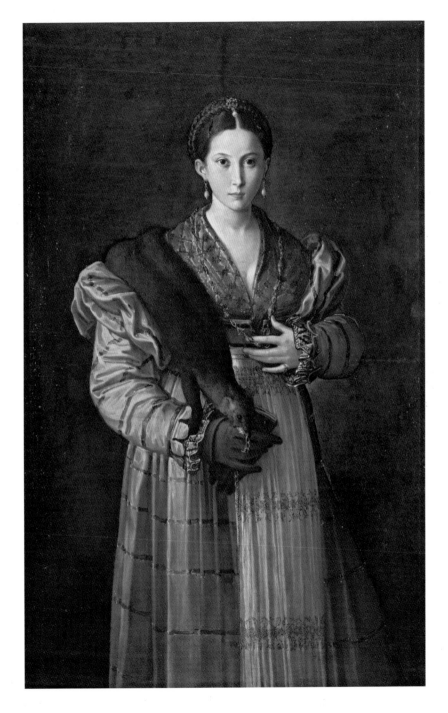

FIG. 6. Parmigianino, *Antea*, ca. 1531–34. Oil on canvas, 136 x 86 cm.
Museo Nazionale di Capodimonte, Naples

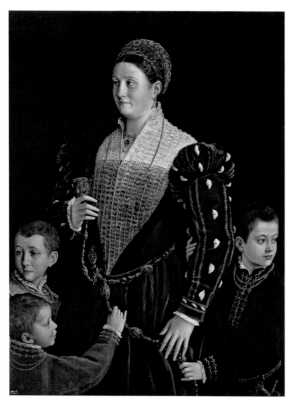

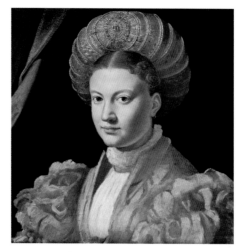

FIG. 8. Parmigianino, *Portrait of Countess Gozzadini* (?), ca. 1530. Oil on panel, 48.5 x 46.5 cm. Kunsthistorisches Museum, Vienna

FIG. 7. Parmigianino (possibly completed by another hand), *Portrait of Camilla Gonzaga, Countess of San Secondo, and Three Sons*, ca. 1535–37. Oil on panel, 128 x 97 cm. Museo del Prado, Madrid

Understanding the *Schiava Turca* as a portrait of a poet raises questions about Parmigianino's inventive process, the ways in which the sitter's status as a poet informs her iconography, and the implications of this interpretation in the larger context of Renaissance poetry and portraiture. As a portrait of a poet, the *Schiava Turca* can enrich our understanding of the culture of women writers of the period. At least in the history of art, something of the vibrant contribution of female poets to Renaissance culture seems to have been overlooked. In modern scholarship, Laura Battiferri (1523–1589), the subject of the celebrated Mannerist portrait by Bronzino (see FIG. 18), has been acclaimed as a

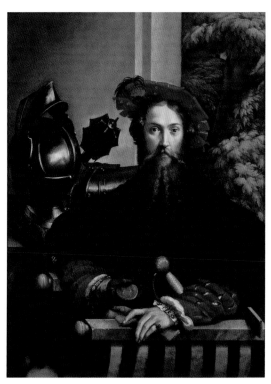

FIG. 9. Parmigianino, *Portrait of Galeazzo Sanvitale,*
ca. 1524. Oil on panel, 109 x 80 cm. Museo
Nazionale di Capodimonte, Naples

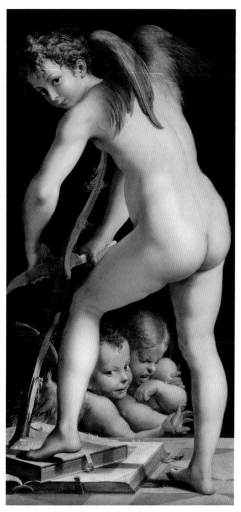

FIG. 10. Parmigianino, *Cupid Carving His Bow,*
ca. 1531–34. Oil on panel, 135.5 x 65 cm.
Kunsthistorisches Museum, Vienna

poet only relatively recently. Vittoria Colonna (1490–1547) is better known as the spiritual friend of Michelangelo than as one of the most influential women writers of her time. Cecilia Gallerani (1473–1536), the subject of *Lady with an Ermine* (see FIG. 17), is better known as Leonardo's sitter and the mistress of Ludovico il Moro than for her poetic accomplishments. Thinking of Parmigianino's *Schiava Turca* not as an inspiration but rather as a poet in her own right calls for its consideration in the context of the culture of women writers and their poetic contributions, as well as their relationships to the painters who portrayed them.

In 1928, when the *Schiava Turca* entered the collection of the Galleria Nazionale di Parma, it was covered in dark varnish.[25] This was removed during restorations that revealed the rich colors, fine play of light and shadow, and variations in texture—both visual and tactile—that are the hallmarks of the painting today.[26] Conservators chose to retain two small areas of the dark varnish to emphasize the "unveiling" of the portrait from its obscuring mask. These are the dark squares visible at the top and bottom edges of the painting (see page 45). The yellow-green background uncovered by the cleaning is unusual but not uncommon in Parmigianino's paintings, which often feature dark backdrops; in fact, some scholars raised unfounded concerns that the removal of the varnish had taken away an originally dark background color.[27] But Parmigianino experimented with unusual backgrounds in several of his portraits. He envisioned Niccolò Vespucci, for example, against a shock of red material and the Count of San Secondo before a mesmerizing graphically patterned brocade.[28] In these paintings, as in the *Schiava Turca*, the artist plays with sharp contrasts between figure and ground. The color of the *Schiava Turca*'s background establishes a chromatic play of complementary colors, at once emphasizing the yellows and golds and brilliantly setting off the symphony of blues in her dress.

When and where Parmigianino painted the *Schiava Turca* is unknown. At present, no documentary evidence establishes a secure date for the picture; but on the basis of style, scholars have largely agreed upon the early 1530s.[29] Parmigianino moved to Bologna in 1527 and from there traveled briefly to Venice in 1530; he probably left Bologna for Parma in 1531, where he remained until shortly before his death in 1540.[30] He could have painted the *Schiava Turca* in any of these cities.[31] Part of the challenge in dating Parmigianino's works

25 On the exchange of the *Schiava Turca* with the Uffizi, see Sorrentino 1928.

26 Renato Pasqui conducted two restorations (in 1954–55 and 1963–64), the details of which were not recorded.

27 For unarticulated backgrounds like that on the *Schiava Turca*, see Ekserdjian 2006, figs. 141, 154, and 155. For concerns regarding the cleaning of the original background color, see Conti 1981, 99 n.2.

28 For *Portrait of a Knight of Malta (Niccolò Vespucci)* in the Niedersächsisches Landesmuseum Hannover and *Portrait of Pier Maria Rossi, Count of San Secondo* in the Museo del Prado, Madrid, see Vaccaro 2002, nos. 47 and 55.

stems from the artist's tendency to reuse and repurpose drawings and compositions for more than one project, sometimes several years apart. In the refined handling and engaged expression of the subject, the *Schiava Turca* resembles *Cupid Carving His Bow* (see FIG. 10). In aspects of costume, it is close to *Portrait of Countess Gozzadini* (see FIG. 8) and *Antea* (see FIG. 6). The face of *Antea*, in turn, appears on an angelic attendant in the *Madonna of the Long Neck*.[32] Of these paintings, only the *Madonna of the Long Neck* can be securely dated but only insofar as it was commissioned in 1534 and left unfinished at the artist's death. A date of around 1534 also seems appropriate for the *Schiava Turca* although leaving it open to sometime in the early to mid-1530s is more prudent.

According to Vasari, Parmigianino's contemporaries likened him to Raphael, but as far as we know, his drawing practice differed from the more clearly sequential processes of that master. More than a thousand drawings have been attributed to Parmigianino. Together, these graphic expressions represent the flowering of his ideas, the rapidity of his thinking, and his facility with all drawing media and techniques. For his subject paintings, he typically executed numerous preparatory drawings in various media. For example, more than twenty drawings survive for the so-called *Vision of St. Jerome* and more than fifty for the *Madonna of the Long Neck*. Many fewer drawings survive for his portraits. So far, only two head studies have been related to the *Schiava Turca*. This small number is consistent with his other portraits, most of which cannot be related to any drawings at all.[33]

The first related drawing, *Study of the Head of a Woman* at the Louvre (FIG. 11), captures the riveting expression of a woman in red chalk over traces of black chalk.[34] The vivacity of her smile, her particularized features, and the artist's sensitive handling of light and

29 Most scholars date the picture to the beginning of the artist's second period in Parma, about 1531–32, with several suggesting a date in the late Bolognese period, 1530–31; only Tentolini 1952, 22, suggests a date in the late 1530s based on the idea that he produced it in Casalmaggiore for a member of the Cavalli family.

30 For his trip to Venice (which must have taken place after 20 March 1530) and the uncertainty over precisely when he moved from Bologna to Parma, either in 1530 or 1531, see Vasari 1966–87, vol. 4, 542; and Popham 1953, 37.

31 His visit to Venice seems to have been short, but it is not impossible that he began the portrait there.

32 Uffizi, Florence. See Neilson 2008, 19; and Vaccaro 2002, no. 36.

33 The exception is *Portrait of Galeazzo Sanvitale*, for which several studies survive.

34 Gnann 2007, no. 890. The white heightening consistently listed among the materials for this drawing is not apparent to me; traces of black chalk are visible beneath the red chalk.

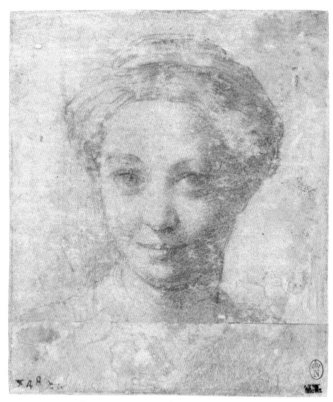

FIG. 11. Parmigianino, *Study of the Head of a Woman,*
ca. 1531–34. Red chalk, 10.1 x 8.7 cm. Musée du Louvre,
Département des Arts Graphiques, Paris

shadow—evident despite the drawing's poor condition—suggest study from a live model. The expression is similar to that of the *Schiava Turca*, as are the turn of the head, contours of the chin and neck, and direction of light.[35] However, the woman wears a cloth bound over her hair rather than a *balzo*, her eyebrows are full rather than plucked to a high arch, and she lacks the ringlets that frame the *Schiava Turca*'s forehead. But the immediacy and intimacy of the *Schiava Turca*'s expression seem to be rooted in this small portrait drawing, which captures the model's very presence as she sat before the artist.

Of almost exactly the same size as the Louvre drawing is *Study of a Woman in a Balzo* (FIG. 12) at the École des Beaux-Arts—a study in red chalk over stylus that was only recently attributed to Parmigianino and related to the *Schiava Turca*.[36] The cool aloofness of

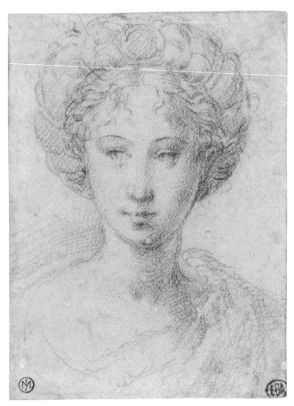

FIG. 12. Parmigianino, *Study of a Woman in a Balzo*,
ca. 1531–34. Red chalk over stylus, 10.3 x 7.6 cm. École
Nationale Supérieure des Beaux-Arts, Paris

this study is entirely different from the warm immediacy of the Louvre drawing. While
the handling of the red chalk is in line with the artist's drawings of the late 1520s and
early 1530s, the composition's specific connection to the *Schiava Turca* is not immediately
apparent.[37] The direction of light is the same in both the drawing and painting, and both
depict women wearing *balzi* with ringlets of hair framing their foreheads. But the drawing
features a different construction for the headdress, which puffs out between the stitched

35 Popham 1971, no. 698, first
 published the drawing in relation
 to the *Schiava Turca*.

36 Brugerolles 2011, no. 13 (entry
 by Emmanuelle Brugerolles and
 Camille Debrabant).

37 I thank Carmen Bambach and
 Mary Vaccaro for discussing this
 drawing with me.

ribs, and the sitter shares nothing of the physiognomy or expression of the *Schiava Turca*. The drawn figure faces forward—both of her ears are visible—and she averts her gaze to the left. Her facial features are highly idealized, even more so than those of the painting. However, the École des Beaux-Arts drawing and the *Schiava Turca* both explore the possibilities of mood, with the cool reserve of the sitter in the drawing offering a distinct alternative to the *Schiava Turca*'s forthright engagement.

The almost identical scale of these two heads (illustrated at actual size) suggests an aspect of Parmigianino's working method. Their scale is similar to other head studies by the artist—for both portraits and subject paintings—and may derive from the physical act of drawing.[38] At this scale, the curved contour of the left side of each face, from ear to chin, maps the range of motion of an average right hand, anchored to the drawing surface, holding a drawing instrument. In other words, the smooth curve of the left side of these faces records the unobstructed motion of the artist's right hand that did not need to be lifted off the page. Thus these head studies may document one way in which the artist's own hand informed the scale of his drawings.

A third drawing to consider in relation to the *Schiava Turca* is Parmigianino's *Bust of a Woman Turned Three-Quarters to the Right* (FIG. 13) in the Devonshire Collection, at Chatsworth, a study not previously connected to the painting or any other project.[39] In this rapid composition sketch, the sitter turns three-quarters toward the viewer in a pose resembling that of the *Schiava Turca*. Drawn in pen and brown ink—with traces of black chalk that mark the contour of the left side of her face, the depressions beneath her eyes, and part of the right sleeve—the smiling figure retains the convention of female sitters in which the head faces the same direction as the body. She wears an ornate headdress, rounded like the *Schiava Turca*'s *balzo*, to which the artist has added a crown of laurel leaves, a conventional marker for the highest of poetic achievements. The use of a laurel crown appears to identify his sitter as a poet and may record an earlier stage in the development of the iconography of the *Schiava Turca*.[40] Replacing the laurel crown with a badge of Pegasus is more subtle, witty, and indeed a more poetic solution. At the same

38 For example, *Studies of a Female Head, a Winged Lion, and Finials*, fig. 4 in this volume.

39 Gnann 2007, no. 700.

40 Jaffé 1994, no. 704, called the drawing a study for a portrait of "a poetess laureate (?)" but does not relate it to the *Schiava Turca*.

41 The Gozzadini portrait originally depicted a fuller view of the sitter, to her hands, but was cut down; a painting by David Teniers of 1651 records the original composition. See Vegelin van Claerbergen 2006, no. 2.

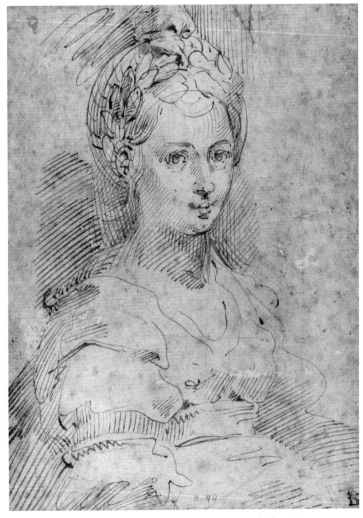

FIG. 13. Parmigianino, *Bust of a Woman Turned Three-Quarters
to the Right,* ca. 1531–34. Pen and brown ink, 14.3 x 10.2 cm.
Devonshire Collection, Chatsworth

time, the Chatsworth drawing also resembles, in reverse, the Countess Gozzadini por-
trait (see FIG. 8).[41] This attests, again, to the non-linearity of Parmigianino's inventive
process in which a single drawing is related to more than one work.

All three drawings demonstrate the diversity and facility of Parmigianino's draftsman-
ship and explore ideas of physiognomy, expression, costume, mood, and iconography that

inform the *Schiava Turca*. The sequence of their creation is not clear. The compositional sketch at Chatsworth may be the earliest: the woman's features are summary and idealized, and Parmigianino is experimenting with the standard iconography of poets. Next may be the École des Beaux-Arts drawing: the expression of the sitter is the antithesis of the lively countenance of the *Schiava Turca*. The woman's *balzo* is decorated with a circular ornament like that in the painting, but it does not bear the emblem of the winged horse. The Louvre head study may be closest in date to the painting because they share a distinctive immediacy. It is likely that Parmigianino produced additional drawings for the *Schiava Turca* that no longer survive.

There are no known drawing studies for the winged horse on the badge of the *Schiava Turca* (see FIG. 2).[42] Because it is realized in a few bold, confident strokes, perhaps preparatory studies were not necessary. Hat badges, like medals and jewels, help to shape the sitter's identity, and Parmigianino frequently included these accessories in his portraits and subject paintings. The recent discovery of the relationship between drawings by Parmigianino and an extant medal supports the idea that Parmigianino engaged directly in the actual production of such ornaments.[43] In the *Schiava Turca*, Parmigianino's realization of the badge of Pegasus in fluid strokes seems the very enactment of the creative impulse that the winged horse represents.

Parmigianino painted the *Schiava Turca* swiftly with thin applications of paint over what appears to be a layer of brownish color, a preparation he often applied to his panels.[44] The brown preparation is most visible at the edge of the *Schiava Turca*'s blue dress as it meets her left shoulder. Black contours, possibly underdrawing applied with a liquid medium and brush, can be seen with the naked eye along the *Schiava Turca*'s face, neck, and shoulders. The painting has not been X-rayed, but results of infrared photography conducted before 2003, which were not captured, suggest that the artist also made changes while painting the panel. A pentimento, or correction, appeared at the sitter's left sleeve, delineating a different shape for the sleeve than appears in the painting. The infrared photography revealed no visible underdrawing in the body.[45] There may not be underdrawing, but it is also possible

42 Parmigianino produced a number of studies of horses, however, for compositions like the *Conversion of Saul* and the so-called *Saturn and Philyra*, fig. 15 in this volume.

43 Two drawings (at the Louvre and the British Museum) may be connected to a medal at the National Gallery of Art, Washington, D.C., I am preparing this material for a forthcoming article.

44 See, for example, Hirst 2000, 44–46.

that the technology used before 2003 was not able to reveal underdrawing or that the underdrawing was executed in a medium not visible with infrared, such as red chalk.

Most of Parmigianino's portraits share the almost life-size scale that is typical of Renaissance portraits. Close comparison of the *Schiava Turca* with *Antea* (see FIG. 6), however, suggests that the two portraits share not only the same scale but also very similar contours, as if they were derived from the same template. At first glance, the portraits seem very different. The sitters' poses are distinct—*Antea* clearly stands while the *Schiava Turca* is probably shown sitting—but the similarities are striking. The women wear almost exactly the same attire: a collarless V-neck partlet, voluminous sleeves worn low at the shoulders, and an apron that hangs from the waist. The articulation of their collarbones and breasts is nearly identical, and their left arms are bent in the same way. Moreover, the contours of the neck and shoulder on their left sides, when superimposed, closely align (FIG. 14). Parmigianino may well have used the same drawings to generate both portraits.

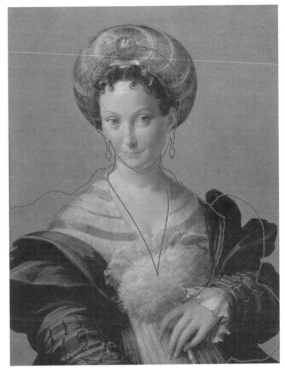

FIG. 14. *Schiava Turca* with outline indicating the approximate contour of *Antea*. Drawing by Joseph Godla

The possibility of shared designs may help to establish the chronology of *Antea* and the *Schiava Turca*. The clarity of *Antea*'s standing pose contrasts with the ambiguity of the *Schiava Turca*, whose seated pose is suggested through the angles at which her apron and dress fall but at the same time is complicated by her active turn toward the left. Parmigianino may have repurposed designs for *Antea* when he created the *Schiava Turca*, cropping the three-quarter length to bust length, adjusting the angles of the dress and

45 At the time of writing, infrared reflectography is scheduled for July 2014 when the *Schiava Turca* is in New York for the exhibition. I thank Ines Agostinelli, conservator at the Galleria Nazionale di Parma, for discussing with me the results of the previous diagnostic imaging, which was not recorded in photographs, as well as the condition of the painting.

apron, modifying the left sleeve, and turning her head. In one of the most perplexing distortions in Parmigianino's oeuvre, *Antea*'s right shoulder and arm are exaggerated out of proportion to the rest of her body. Deviating from the distortion of *Antea*'s right side, Parmigianino depicted the *Schiava Turca*'s right shoulder and arm in proper proportion to her body, leaving her right hand out of sight.

The similarities between the two portraits provide new insights into Parmigianino's creative process. Although his portraits exhibit great variety, some may, in fact, have very similar designs. This is unlike portraits by Raphael, such as *La Fornarina* and the *Donna Velata*, in which the artist emphasizes differences in attire, mode, and sentiment by giving his subjects similar compositions and poses.[46] Raphael exploits commonalities to showcase distinctions; Parmigianino, instead, generates distinctive portraits whose commonalities are evident only through close study.

The varied means and swift assurance with which Parmigianino handles paint in the *Schiava Turca* echo the diverse modes and materials he habitually employed in his preparatory designs. On a single panel, Parmigianino's painting techniques range from extremely fine, linear application in areas such as the delicate gold ring to thick, creamy brushstrokes, as in the plumes of the fan. Raised ridges of paint on the *balzo* have enough relief to cast shadow. Conversely, the edge of her left sleeve, where the blue dress meets the woven shirt, is rendered with one broad stroke of translucent, glaze-like paint that reveals the brown preparation beneath. Through his masterful manipulation of oil on the panel, Parmigianino is able to convey the full range of effects he achieved in his preparatory drawings of red and black chalk, stylus, and pen and ink. He expresses the diverse effects of his drawings in paint.

46 For *Donna Velata* at the Galleria Palatina, Florence, and *La Fornarina* at the Galleria Nazionale d'Arte Antica, Rome, see Meyer zur Capellen 2008, vol. 3, nos. 73 and 79.

To mark a sitter as a poet, a painter might select an attribute that identified his or her profession: the sitter could hold a pen, carry a book of verse, or display a sheet of poetry. These items appear frequently in Renaissance portraits both of people who were known as writers and those who were not. The *Schiava Turca*, however, holds an unlikely ostrich-feather fan, an accessory popular in Northern Italy among noblewomen and courtesans but not featured in any other portrait of the period as prominently as it is here. The Chatsworth sheet (see FIG. 13) suggests that Parmigianino experimented with iconography in his preparatory drawings. A suite of lost drawings may record his transformation of a standard laurel crown interestingly wrapped around a *balzo* into the inventive Pegasus badge. The *Schiava Turca*'s fan might also be interpreted with Parmigianino's creative wit in mind. Its ostrich feathers—*le piume* or *le penne* in Italian—can be read as a visual pun for a pen, which, in the singular, would be called *la piuma* or *la penna*, in the kind of wordplay that occurs in poetry of the period. One example, written by one female poet to another—Lucia Dell'Oro Bertani (1521–1567) to Veronica Gambara (1485–1550)—does exactly this. Praising the poetic talents of Gambara and Vittoria Colonna, Bertani evokes the classical female poets Sappho and Corinna and their learned pens—"dotte piume"—as a pun on feathers or wings:

Ebbe l'antica e gloriosa etade
Saffo e Corinna, che con dotte piume
s'alzaro insino al bel celeste lume
per molte, degne, e virtuose strade.

The glorious age of antiquity had Sappho and Corinna, who with their learned pens [punning on the secondary sense of feathers or wings] rose to the lovely light of the heavens by many worthy and virtuous routes.[47]

By using wordplay in his portrait of a poet, Parmigianino participates in the courtly culture of Northern Italy, whose members delighted in witty pictorial and poetic play. Moreover, he engages in the *paragone* between poetry and painting by expressing the sitter's beauty with his paint and employing a poetic strategy to do so. The ostrich-feather fan

47 Transcribed and translated in Cox 2008, 76, who also points out the pun. The poem likely dates to before 1547, the year of Colonna's death.

serves two functions: as a luxury item, it signals her social status among the courtly elite; as a play on words, it may address her identity as a poet while also emphasizing the artist's own poetic dexterity and genius.

There may also be a specifically feminine reading of Parmigianino's symbolism. The winged horse Pegasus is well known as an emblem of poetic inspiration, primarily because of Bembo's fame and his adoption of it for the reverse of his portrait medal. There is, however, another, albeit more obscure, reading of the winged horse. Pegasus created the Hippocrene spring, sacred to Apollo and the Muses; but a second spring, the Aganippe, also gushed forth on Mount Helicon at the strike of another winged horse's hoof. Named after its magical equine creator, the Aganippe was a fountain of poetic inspiration, especially for women.[48] The poem cited above, written by Bertani in praise of the poets Veronica Gambara and Vittoria Colonna, goes on to evoke this particularly feminine source:

Or due, che allor il crin cinge e bontade
non pur fan d'Aganippe nascer fiume,
ma spengono ogni falso e rio costume
con opre eccelse, eterne, uniche e rade

Now two ladies, whose locks are crowned with laurel and goodness not only make Aganippe gush forth once more, but extinguish every false and wrongful habit with their splendid, eternal, unique, and rare deeds[49]

The name *Hippocrene*, translating to "fountain of the horse" (*hippos*, horse, and *kríni*, fountain), conveys the myth of its creation. *Aganippe*, however, may instead connote the character of its creator as a "gentle horse" (*aganos*, gentle, and *hippos*, horse).[50] The *Schiava Turca's* winged horse is conventionally identified as the stallion Pegasus, but it could very well be Aganippe, which would have been fitting for a portrait of a woman writer.

The identity of another of Parmigianino's winged horses similarly warrants reinterpretation. Scholars have long debated the subject of a painting formerly in the Stanley Moss

48 Ovid mentions Aganippe in passing with Hippocrene, *Metamorphoses,* v: 312. For a sixteenth-century source for this myth, see Caracciolo 1589, vol. 2, 120: "era accanto a questa fontana un'altra; che pur dal cavallo preso il nome si diceva Aganippe, parimente dedicata alle Muse, che se ne dicevano Aganippide" (next to this font [the Hippocrene] was another that also took its name from a horse, called Aganippe, also dedicated to the Muses, called Aganippide).

49 Transcribed and translated in Cox 2008, 76.

50 I thank Zoë Tan and Colin Webster for discussing this with me. Aganippe is also the name of the Nymph of this spring.

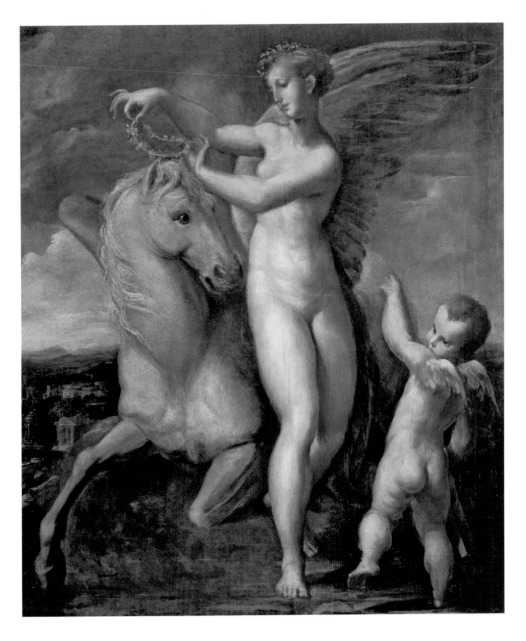

FIG. 15. Parmigianino, *Saturn and Philyra*, ca. 1534. Oil on panel, 75.6 x 64.1 cm. Formerly Collection Stanley Moss, New York

collection that depicts a winged horse being crowned by a female nude, with Cupid in attendance (FIG. 15).[51] It was known as *Pegasus and a Muse* until A. E. Popham designated it as *Saturn and Philyra*, based in part on the painting's resemblance to a design for an engraving of that subject by Rosso Fiorentino (1494–1540).[52] In the myth of Saturn and Philyra, Saturn (or rather, the Greek Cronus) pursues an affair with the nymph Philyra. In order to hide his transgressions from his wife Rhea, Saturn transforms himself into a horse. In Rosso's design, the iconography is clear: Rosso depicts Saturn as a horse; Philyra in human form; and Cupid, whose presence signals the amorous affair, carrying a scythe, an attribute of Saturn. Parmigianino may have imitated Rosso's composition in his painting, but he complicated its clear iconography. In the painting, as in related drawings, Parmigianino depicts not an earthly horse but a winged one. Cupid no longer carries Saturn's scythe, and the figures, rather than embracing, enact a coronation. He sets his scene on an elevated terrain, looking down upon a Greek city. Whereas Rosso's powerful horse, an incarnation of the great god, rears up forcefully and meets his lover eye-to-eye, Parmigianino's winged horse bows down gently, low to the ground, to receive a crown of flowers from the female who is herself already crowned. Parmigianino emulates Rosso's depiction while dissolving its erotic urgency. He portrays both horse and woman crowned in a scene of balletic elegance. The subject of Parmigianino's painting may be interpreted as the "gentle horse" Aganippe crowned by a muse, an episode that logically would have taken place on Mount Helicon, home of the poetic fonts. To a courtly audience well versed in humanist texts, the presence of Cupid need not signify a love affair. It could instead identify the scene's location since the sanctuary of Cupid was located at the foot of Mount Helicon.[53] Thus Cupid attends the coronation of the winged creator of the source of poetic inspiration, which so often generates words of love.

At least six sheets of composition studies record Parmigianino's exploration of the subject through various configurations of the winged horse and female figure.[54] One drawing in Chatsworth includes Cupid flying above, aiming an arrow at the winged horse and

51 Vaccaro 2002, no. 35.

52 Carroll 1987, no. 43.

53 For example, in Pausanias, *Description of Greece*, Book 9, Chapter 27, at Thespiae, at the foot of Mount Helicon.

54 Popham 1971, nos. 718, 510, 245, 654, 655, and 387; Franklin 2003, nos. 77–81.

female embracing below; this has been seen to confirm Popham's interpretation of the painting as Saturn and Philyra because Cupid shooting his arrow at a pair clearly denotes the presence of lovers.[55] The drawing may record Parmigianino's exploration of the subject of Saturn and Philyra since he was likely inspired by Rosso's design; but in other drawings and the painting, he may

FIG. 16. Parmigianino, *Schiava Turca*, detail of chain

have conveyed another subject with the same three figures, shifting from an encounter of lovers to a triumph of poetic force, from the erotic to the intellectual and back again. The painting need not be seen as Saturn and Philyra to the exclusion of Aganippe crowned and vice versa; Parmigianino toys with the possibilities and potentialities of both. The painting and its drawings attest that Parmigianino deeply explored the mythology and iconography of poetic inspiration—indeed that he engaged the processes of poetic invention in his art. Like the *Schiava Turca* portrait, this mythological painting is among Parmigianino's most poetic works.

In the iconography of the *Schiava Turca*, the delicate gold links embedded in her right sleeve (FIG. 16) evoke the central poetic theme of the power of love to enchain its victim. The practical function of inserting a chain into a sleeve—if there was one—is unknown, and this same detail does not seem to appear in other portraits of the period.[56] The chain's purpose in the painting may be purely symbolic. Gold chains usually connected items such as fans to a belt around a woman's waist, but the sitter's chain does not appear to connect to anything:[57] the links wrap around her arm but, perplexingly, seem to chain the sitter only to herself. This parallels a poem by the Modenese poet Panfilo Sasso, who alludes to the captivity of a sitter in a painted portrait, thereby underscoring the intertwining of

55 Devonshire Collection, Chatsworth (inv. no. 788 verso). See Ekserdjian 2006, 101; and Jaffé 1994, no. 710. I thank David Ekserdjian for discussing the drawing and painting with me.

56 Chains worn as bracelets around the wrist are seen in portraits of the period, but a chain entwined in the slashes of the sleeve does not, to my knowledge, appear in any other portrait.

57 Conservator Ines Agostinelli confirms that there is no evidence on the panel that the painting was cut down.

the arts of painting and poetry.[58] It might also allude to the idea of Love enchained by Chastity that appears in Petrarch's *Triumph of Chastity*. How the *Schiava Turca*'s chain should be interpreted is unclear. Parmigianino may have intended it to be more evocative than direct. Perhaps the *Schiava Turca* was meant to engage her courtly audience in a game of interpretation or invention that echoed the artist's own creative process.

The attributes of the *Schiava Turca*—the hat badge, the fan, and the chain—operate equivocally. They are at once items of Renaissance fashion and markers of more complex significance about the identity of the sitter. The winged horse on her headdress and the fan pointed toward her chest, moreover, emphasize the sites of creative power: the head and the heart, the intellect and the soul. They may even be seen in terms of poetic modes: the lofty mythological emblem engages the realm of the more serious Petrarchan mode while the playful, frivolous fan, drawing attention to her breasts, may be seen to engage the burlesque. The very representation of these attributes becomes a game in itself, engaging the painting's viewers in a witty exchange. These are the possibilities of Parmigianino's poetry, which draws on the wit, erudition, and playfulness of Northern Italian court culture.

A POET REBORN

Identifying the *Schiava Turca* as a portrait of a poet brings it into conversation with other Renaissance portraits of women writers. Leonardo's portrait of Cecilia Gallerani, *Lady with an Ermine* (FIG. 17), and Agnolo Bronzino's *Portrait of Laura Battiferri* (FIG. 18) are two of the best-known examples, while many others remain clouded in uncertainty as to their sitters' identities.[59] Leonardo activates Cecilia Gallerani's body in a manner

58 "Tu m'hai vivo in catena e pinto in cassa/ tanto che in quasi ogni modo ho tracto" (You have chained me in life and held me in painting, in a wooden box/ So that in every way I am racked); Bolzoni 2010, 173–75 (translation is hers). I thank Lina Bolzoni for discussing this peculiar poem with me and for pointing out that its tragic atmosphere differs from the lightness of the *Schiava Turca*.

59 Other examples include portraits by Sebastiano del Piombo, Correggio, and Leonardo. On Sebastiano's *Portrait of Vittoria Colonna* (?) (Museu Nacional d'Art de Catalunya, Colección Cambó, Barcelona), see Strinati 2008, no. 39. On Correggio's *Portrait of Ginevra Rangone* (?) (Hermitage, St. Petersburg), see Ekserdjian 1997, 6 and 75; and Periti 2004. Correggio's sitter has also been called Veronica Gambara, but this is no longer accepted. For Leonardo's *Portrait of Ginevra de' Benci* (National Gallery of Art, Washington, D.C.), the identity of the sitter is not in question, but Garrard 2006 discusses the possibility of her being a poet.

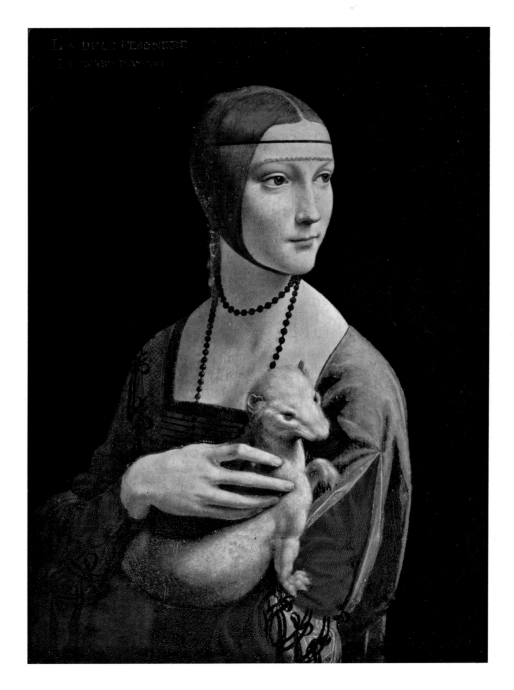

FIG. 17. Leonardo da Vinci, *Lady with an Ermine*, ca. 1489–90. Oil on panel, 54.8 x 40.3 cm.
Princes Czartoryski Foundation, on deposit at the National Museum, Cracow

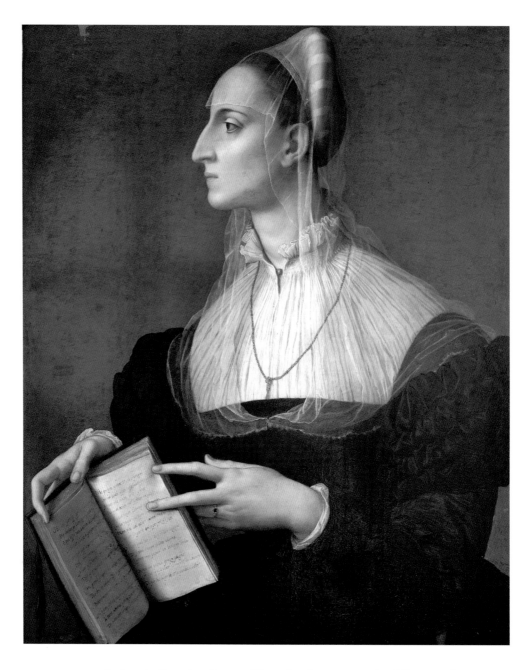

FIG. 18. Agnolo Bronzino, *Portrait of Laura Battiferri,* ca. 1555–60. Oil on panel, 83 x 60 cm. Palazzo Vecchio, Florence

unprecedented in female portraiture and in so doing seems to convey her creative force; Parmigianino emulates this vitality in the *Schiava Turca.* Later, Bronzino evokes the distinct profile of Dante in the features of his *Portrait of Laura Battiferri* in order to express her poetic genius.[60] In the *Schiava Turca,* Parmigianino endows his poet with an expression similar to the one he gives to the god of love. These appropriations of male conventions in female portraits are informed by the social context of women writers in the Renaissance. A poem by Veronica Gambara to another woman poet (Vittoria Colonna) suggests that female poets aspired to attain qualities of both the feminine and masculine, of both Athena (Pallas or Palla) and Apollo (Phoebus or Febo):

> *Il sesso nostro un sacro e nobil tempio*
> *Dovria, come già a Palla e a Febo, farvi*
> *Di ricchi marmi e di finissim'oro.*

> *Our sex should erect a sacred and noble temple to you, as once they were raised to Pallas and Phoebus, adorned with rich marbles and the most refined gold.*[61]

Gambara invokes Apollo, indeed equates Apollo and Athena, in her praise for Colonna. To the elite audience that would understand Parmigianino's pictorial play of male and female conventions and word games, the painting would present an ideal of the woman poet.

This reading of Parmigianino's portrait calls for a rethinking of aspects of humanist poetic culture in the 1530s. Although earlier humanist writers saw Pegasus as a signifier, no one is better known in association with the winged horse than Bembo.[62] Bembo's Pegasus emblem is virtually interchangeable with his own likeness. Accepting a date for the *Schiava Turca* of around 1534 means that Parmigianino's portrait predates Bembo's medal, which must have been produced after 1539.[63] Parmigianino and Bembo were in the same cities at the same time—in Rome before the Sack in 1527 and in Bologna during the coronation of Charles v—and Parmigianino certainly had contact with members of Bembo's circle. Both

60 Plazzotta 1998.

61 Transcribed and translated in Cox 2008, 69.

62 Pegasus appears on the reverse of the portrait medal by Girolamo

Ridolfi, dated ca. 1485, National Gallery of Art, Washington, D.C. (1991.198.1) in Pollard 2007, vol. 1, no. 297. On Bembo's father Bernardo and Pegasus, see Beltramini 2013, 379.

63 See Beltramini 2013, no. 6.13 (entry by Davide Gasparotto). For Benvenuto Cellini's claim that he produced a medal of Bembo with a Pegasus crowned with myrtle in 1537, see Gasparotto in Beltramini 2013, 378.

Parmigianino's sitter and Bembo adopted the winged horse as an emblem in these years, suggesting a possible connection between the two. This raises questions about the context in which Bembo chose Pegasus as his emblem, especially since this was the second of his portrait medals and Pegasus did not appear on his first medal of 1532.[64]

A candidate for the sitter of the *Schiava Turca* would be a female writer of high social stature in the area around Bologna or Parma in this period—perhaps a poet connected to the circle of Bembo. There are several possibilities, but one particular individual seems most likely: Veronica Gambara. A celebrated poet tied to prominent cultural figures such as Isabella d'Este, Charles v, Ludovico Ariosto, and certainly Bembo, Gambara had ample opportunity to meet Parmigianino.[65] For most of her life, she lived in Correggio, which is about twenty miles from Parma; in fact, she ruled Correggio from 1518 until her death. She visited Parma in 1522 (when Parmigianino was there) and was in Bologna from late 1528 until after the coronation of Charles v in 1530 (Parmigianino was there from 1527 to 1530 or 1531). In Bologna, Gambara hosted salons attended by Bembo and his circle.[66] Her relationship with Bembo was close; they exchanged letters and poems for many years, and Bembo published her poetry in his *Rime*.[67] She was widowed in 1518 and never remarried. In its simplicity and understatement, lacking any ostentation or even a stone, the faint gold band on the ring finger of the *Schiava Turca* is unlike any other painted by Parmigianino; such a delicate statement of marriage may allude to the status of a widow, now married to the memory of her husband. The chain in the *Schiava Turca's* sleeve evokes the idea of Love enchained by Chastity, thus underscoring her virtuous character. Gambara seems to have had a personal relationship with Parmigianino's former master, the artist Antonio Allegri (called Correggio), commending Correggio's painting to Isabella and introducing him to Charles v, and may have commissioned the artist to decorate rooms of her

64 Beltramini 2013, nos. 5.1–5.3 (entry by Davide Gasparotto).

65 On Gambara, see Corso 1566, 39–45; Rizzardi 1759; and Cox 2008, 64–79; for bibliography, see McIver 2001, 161 n. 17. Gambara was close friends with Isabella, hosted Charles v twice in Correggio, and was praised by Ariosto in *Orlando Furioso* (canto XLVI).

66 Rizzardi 1759, LXIV, writes of the Casa di Veronica: "più che albergo d'una illustre Principessa sembrava un domicilio delle Muse, e una pubblica Academia" (more than the hostel of an illustrious princess it seemed a domicile of the Muses, and a public Academy).

67 The poem "A l'ardente desio ch'ognor m'accende" was dedicated to Bembo and published in the second edition of his *Rime* in 1535. On Gambara and Bembo, see Dilemmi 1989.

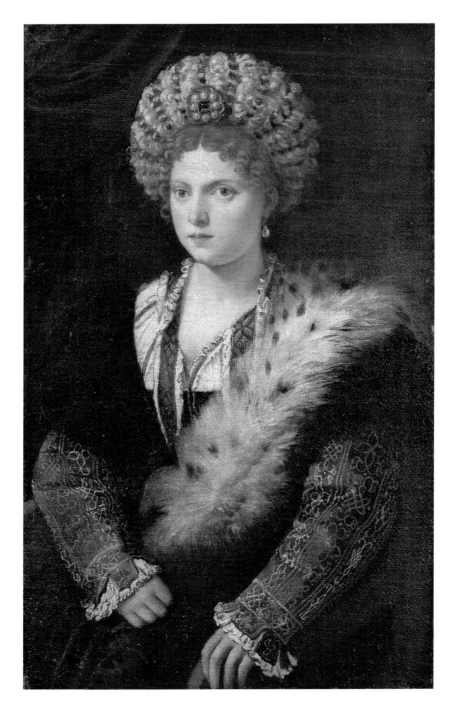

FIG. 19. Titian, *Portrait of Isabella d'Este*, 1534–36. Oil on canvas, 102.4 x 64.7 cm. Kunsthistorisches Museum, Vienna

so-called Casino delle Delizie, her pleasure villa (now destroyed).[68] Correggio died in 1534. If Parmigianino depicted Gambara as the *Schiava Turca*, it may be that he did so after the death of her favored artist in 1534. Gambara's sixteenth-century biographer paralleled Gambara and Bembo, praising Gambara as a model for women poets as Bembo was for men.[69] Gambara's close connection to Bembo may help to explain why emblems of a winged horse feature prominently in both Parmigianino's portrait and on Bembo's medal in these years.

One problem with identifying Gambara as Parmigianino's sitter might seem to be that the *Schiava Turca* appears to be a young woman, and Gambara, who was born in 1485, was by the time of its painting around fifty years old. Titian's *Portrait of Isabella d'Este* (FIG. 19), painted when Isabella was about sixty years old but depicting her as significantly younger, is an important comparison for the *Schiava Turca*.[70] Both were painted at about the same time in the mid-1530s. Veronica and Isabella were close correspondents. No known image of Gambara survives to corroborate her identification as Parmigianino's sitter—though even if one did, it is notoriously difficult to compare physical features of a sitter from one portrait to another. If the *Schiava Turca* cannot be definitively identified as Gambara, interpreting her status as a poet may at least bring us closer to her identity.

Like other portraits of women poets, Parmigianino's *Schiava Turca* complicates the traditional *paragone* between painting and poetry. The beautiful sitter is more than the muse, more than the subject of competition between the painter's brush and the poet's pen. She herself holds the pen; it is her poetry with which the painter competes. And yet Parmigianino plays an ultimate reversal. In his portrait, the sitter becomes the muse again, inspiring him, the artist, to express his great painterly and poetic potential—for Parmigianino too becomes the poet in paint. The *Schiava Turca* itself represents a witty game of painter, poet, and muse. In the end, however, Parmigianino's painted poetry has the last word.

68 On Gambara as patron of art, see McIver 2001, 162–63. The earliest known reference to Gambara's Casino delle Delizie is Rizzardi 1759, LXXV.

69 Corso 1566, 39.

70 Brown 1990, no. 25. I thank David Ekserdjian for pointing out the distinction that Parmigianino produced drawings in preparation for the *Schiava Turca* while Titian based his portrait on an earlier painting of Isabella.

Schiava Turca PROVENANCE, EXHIBITION HISTORY, AND LITERATURE

Provenance: Cardinal Leopoldo de' Medici [1617–1675], Florence, before 1675; Galleria degli Uffizi, Florence, by 1704; Galleria Nazionale di Parma, since 1928.

Exhibition History: Reggia di Venaria Reale, Turin, and Palazzo Pitti, Florence, 2011, *La bella Italia: Arte e identità delle città capitali,* no. 8.1.1; Galleria Nazionale di Parma and Kunsthistorisches Museum, Vienna, 2003, *Parmigianino und der europäische Manierismus,* no. II.2.28; Galleria Nazionale di Parma, 1948, *Mostra Parmense di dipinti noti ed ignoti dal XIV al XVIII secolo,* no. 78; Palazzo della Pilotta, Parma, 1935, *Mostra del Correggio,* no. 56; Royal Academy of Arts, Burlington House, London, 1930, *Exhibition of Italian Art,* 1200–1900, no. 749.

Select Literature: Vaccaro 2013, 70; Brugerolles 2011, no. 13; De Rossi 2007; Gnann 2007, 282–84; Ekserdjian 2006, 150–54, 160–61; Fornari Schianchi 2003; Ferino-Pagden and Fornari Schianchi 2003, no. II.2.28; Sgarbi 2003, 138; Di Giampaolo and Fadda 2003, no. 47; Pommier 2002, 64; Vaccaro 2002, no. 51 (and for previous literature).

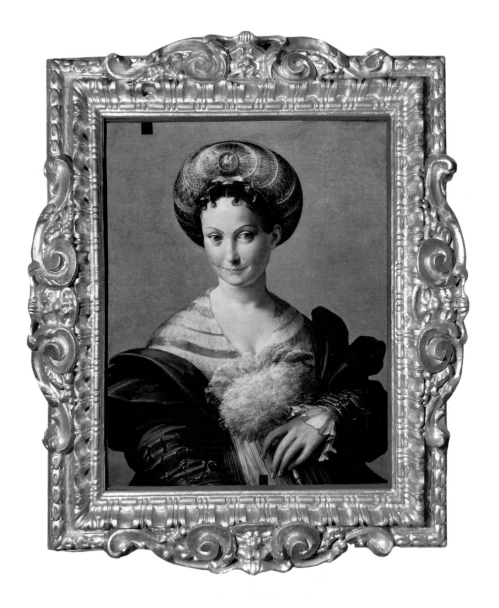

The *Schiava Turca* is shown here in its present condition, with squares of dark varnish at the top and bottom edges. These were retained by the Galleria Nazionale di Parma's then conservator Renato Pasqui to document the condition of the painting prior to removal of varnish during restorations in 1954–55 and 1963–64. The sixteenth-century gilt frame was restored in 2003 by Ines Agostinelli, conservator at the Galleria Nazionale di Parma.

BIBLIOGRAPHY

Beltramini 2013
Beltramini, Guido, et al., eds. *Pietro Bembo e l'invenzione del Rinascimento.* Exh. cat. Venice: Marsilio Editoriale; Padua: Gruppo Editoriale Zanardi, 2013.

Bolzoni 2008
Bolzoni, Lina. *Poesia e ritratto nel Rinascimento.* Rome: Editori Laterza, 2008.

————. **2010**
Bolzoni, Lina. *Il cuore di cristallo. Ragionamenti d'amore, poesia e ritratto nel Rinascimento.* Turin: Giulio Einaudi Editore, 2010.

Brown 1990
Brown, David Allan, et al. *Titian, Prince of Painters.* Exh. cat. Venice: Marsilio Editori, 1990.

Brugerolles 2011
Brugerolles, Emmanuelle, ed. *Parmesan: Dessins et gravures en clair-obscur. Carnets d'études 19.* Exh. cat. Paris: École Nationale Supérieure des Beaux-Arts, 2011.

Caracciolo 1589
Caracciolo, Pasqual. *La gloria del cavallo.* Venice: Moretti, 1589.

Carroll 1987
Carroll, Eugene. *Rosso Fiorentino: Drawings, Prints, and Decorative Arts.* Exh. cat. Washington, D.C.: National Gallery of Art, 1987.

Ceruti Burgio 1999
Ceruti Burgio, Anna. "La 'Schiava turca' e 'La Madonna dal collo lungo' del Parmigianino e la poesia di Andrea Baiardi." *Il carrobbio* 25 (1999): 35–41.

Chimenti 1995
Chimenti, Antonia. *Veronica Gambara: Gentildonna del Rinascimento: Un intreccio di poesia e storia.* Reggio Emilia: Magis Books, 1995.

Chiusa 2001
Chiusa, Maria Cristina. *Parmigianino.* Milan: Electa, 2001.

Conti 1981
Conti, Alessandro. "Vicende e cultura del restauro." In *Storia dell'arte italiana,* vol. 10, 39–112. Turin: Giulio Einaudi Editore, 1981.

Corso 1566
Corso, Rinaldo. *Vita di Giberto Terzo di Correggio detto Il Difensore, colla Vita di Veronica Gambara.* Ancona: Appresso Astolfo de Grandi Veronese, 1566.

Cox 2008
Cox, Virginia. *Women's Writing in Italy, 1400–1650.* Baltimore: The Johns Hopkins University Press, 2008.

Cranston 2000
Cranston, Jodi. *The Poetics of Portraiture in the Italian Renaissance.* Cambridge: Cambridge University Press, 2000.

Cropper 1976
Cropper, Elizabeth. "On Beautiful Women, Parmigianino, Petrarchismo, and the Vernacular Style." *Art Bulletin* 58, no. 3 (Sept. 1976): 374–94.

De Rossi 2007
De Rossi, Anna. "La misteriosa 'Schiava turca' del Parmigianino: Giulia Gonzaga Colonna." *Aurea Parma* 91, no. 2 (2007): 159–76.

46

Di Giampaolo and Fadda 2003
Di Giampaolo, Mario, and Elisabetta Fadda. *Parmigianino: Catalogo completo dei dipinti.* Santarcangelo di Romagna: Idea Libri, 2003.

Dilemmi 1989
Dilemmi, Giorgio. "'Ne videatur strepere anser inter olores': le relazioni della Gambara con il Bembo." In *Veronica Gambara e la poesia del suo tempo nell'Italia settentrionale*, edited by Cesare Bozzetti, Pietro Gibellini, and Ennio Sandal, 23–36. Florence: Stamperia Editoriale Parenti, 1989.

Ekserdjian 1997
Ekserdjian, David. *Correggio.* New Haven and London: Yale University Press, 1997.

————. **2000**
Ekserdjian, David. "A Portrait of Niccolò Vespucci by Parmigianino." *Apollo* 151, no. 460 (June 2000): 36–42.

————. **2006**
Ekserdjian, David. *Parmigianino.* New Haven and London: Yale University Press, 2006.

Ferino-Pagden and Fornari Schianchi 2003
Ferino-Pagden, Sylvia, and Lucia Fornari Schianchi. *Parmigianino und der europäische Manierismus.* Vienna: Kunsthistorisches Museum and Silvana Editoriale, 2003.

Fomichova 1992
Fomichova, Tamara D. *The Hermitage Catalogue of Western European Painting—Venetian Painting, Fourteenth to Eighteenth Centuries.* Moscow: Iskusstvo Publishers; Florence: Giunti Publishing Group, 1992.

Fornari Schianchi 1998
Fornari Schianchi, Lucia. *Galleria Nazionale di Parma: Catalogo delle opere del Cinquecento.* Milan: Franco Maria Ricci, 1998.

————. **2003**
Fornari Schianchi, Lucia. *Parmigianino: La Schiava Turca.* Cinisello Balsamo: Silvana Editoriale; Milan: Il Sole 24 Ore, 2003.

Franklin 2003
Franklin, David. *The Art of Parmigianino.* Exh. cat. New Haven: Yale University Press; Ottawa: in association with the National Gallery of Canada, 2003.

Garrard 2006
Garrard, Mary D. "Who Was Ginevra de' Benci? Leonardo's Portrait and Its Sitter Recontextualized." *Artibus et Historiae* 27, no. 53 (2006): 23–56.

Gnann 2007
Gnann, Achim. *Parmigianino: Die Zeichnungen.* 2 vols. Petersberg: M. Imhof, 2007.

Gnignera 2010
Gnignera, Elisabetta. *I Soperchi ornamenti: Copricapi e acconciature femminili nell'Italia del Quattrocento.* Siena: Protagon Editori, 2010.

Goretti 2009
Goretti, Paola. "Il gusto del vestire nelle corti padane tra Cinque e Seicento." *I Castelli di Yale* 10, no. 10 (2009): 51–64.

Hackenbroch 1996
Hackenbroch, Yvonne. *Enseignes: Renaissance Hat Jewels.* Florence: Studio per Edizioni Scelte, 1996.

Hirst 2000
Hirst, Michael. "A Portrait of Lorenzo Pucci by Parmigianino." *Apollo* 151, no. 460 (June 2000): 43–47.

Jaffé 1994
Jaffé, Michael. *The Devonshire Collection of Italian Drawings. Bolognese and Emilian Schools.* London: Phaidon Press, Ltd., 1994.

Leino 2013
Leino, Marika. *Fashion, Devotion and Contemplation: The Status and Functions of Italian Renaissance Plaquettes.* Oxford, Bern, Berlin, Brussels, Frankfurt am Main, New York, Vienna: Peter Lang, 2013.

Levi-Pisetzky 1966
Levi-Pisetzky, Rosita. *Storia del costume in Italia.* vol. 3: *Il Cinquecento.* Milan: Istituto Editoriale Italiano, 1966.

McIver 2001
McIver, Katherine A. "Two Emilian Noblewomen and Patronage Networks in the Cinquecento." In *Beyond Isabella: Secular Women Patrons of Art in Renaissance Italy,* edited by Sheryl E. Reiss and David Wilkins, 159–76. Kirksville, MO: Truman State University Press, 2001.

Meyer zur Capellen 2008
Meyer zur Capellen, Jürg. *Raphael: A Critical Catalogue of His Paintings.* 3 vols. Landshut: Arcos, 2008.

Neilson 2008
Neilson, Christina. *Parmigianino's "Antea": A Beautiful Artifice.* Exh. cat. New York: The Frick Collection, 2008.

Periti 2004
Periti, Giancarla. "From Allegri to Laetus-Lieto: The Shaping of Correggio's Artistic Distinctiveness." *Art Bulletin* 86, no. 3 (Sept. 2004): 459–76.

Plazzotta 1998
Plazzotta, Carol. "Bronzino's Laura," *The Burlington Magazine* 140 (1998): 251-63.

Pollard 2007
Pollard, John Graham, with the assistance of Eleonora Luciano and Maria Pollard. *Renaissance Medals.* 2 vols. Washington, D.C.: National Gallery of Art, 2007.

Pommier 2002
Pommier, Edouard. "Riflessioni sul Parmigianino ritrattista." In *Parmigianino e il manierismo europeo. Atti del Convegno internazionale di studi—Parma 13–15 giugno 2002,* edited by Lucia Fornari Schianchi, 58–66. Milan: Silvana Editoriale, 2002.

Popham 1953
Popham, A. E. *The Drawings of Parmigianino.* New York: Beechhurst Press, 1953.

———. 1971
Popham, A. E. *Catalogue of the Drawings of Parmigianino.* 3 vols. New Haven, Published for the Pierpont Morgan Library [by] Yale University Press, 1971.

Rizzardi 1759
Rizzardi, Felice. *Rime e lettere di Veronica Gambara.* Brescia: Giammaria Rizzardi, 1759.

Sgarbi 2003
Sgarbi, Vittorio. *Parmigianino.* Milan: Rizzoli/Skira, 2003.

Sorrentino 1928
Sorrentino, Antonio. "I recenti acquisti della R. Galleria." *Aurea Parma* 12 (Jan.–Feb. 1928): 135–46.

Strinati 2008
Strinati, Claudio, et al., eds. *Sebastiano del Piombo: 1485–1547.* Exh. cat. Milan: F. Motta, 2008.

Syson 2011
Syson, Luke, with Larry Keith et al. *Leonardo da Vinci: Painter at the Court of Milan.* Exh. cat. London: National Gallery Company, 2011.

Tentolini 1952
Tentolini, Renzo. "L'ultima dimora del Parmigianino a Casalmaggiore." *Parma per l'arte* 2 (1952): 20–29.

Vaccaro 2002
Vaccaro, Mary. *Parmigianino: The Paintings*. Turin and New York: Umberto Allemandi, 2002.

———. 2013
Vaccaro, Mary. "True Beauties." *Apollo* (Dec. 2013): 66–71.

Vasari 1966–87
Vasari, Giorgio. *Le vite de' più eccellenti pittori, scultori e architettori, nelle redazioni del 1550 e 1568*, edited by Rosanna Bettarini and Paola Barocchi. 6 vols. Florence: Sansoni, 1966–87.

Vegelin van Claerbergen 2006
Vegelin van Claerbergen, Ernst, ed. *David Teniers and the Theatre of Painting*. Exh. cat. London: Courtauld Institute of Art Gallery in association with Paul Holberton Publishing, 2006.

Wolk-Simon and Bambach 2010
Wolk-Simon, Linda, and Carmen B. Bambach. *An Italian Journey: Drawings from the Tobey Collection, Correggio to Tiepolo*. Exh. cat. New York, New Haven, and London: The Metropolitan Museum of Art and Yale University Press, 2010.

PHOTOGRAPHY CREDITS

Unless otherwise stated, all photographs of artworks appear by permission of the owners indicated in their captions. The following credits apply to images for which separate acknowledgment is due.

FIGS. 1, 2, and 16 and back cover: By permission of the Ministero per i Beni e le Attività Culturali e del Turismo—Galleria Nazionale di Parma. Frontispiece and FIGS. 8, 10, and 19: © Kunsthistorisches Museum, Vienna. FIG. 3: Mondadori Portfolio / Electa / Art Resource, NY. FIG. 6: © Fototeca della Soprintendenza Speciale per il PSAE e per il Polo Museale della città di Napoli. FIG. 7: © Museo Nacional del Prado / Art Resource, NY. FIGS. 9 and 18: Alinari / Art Resource, NY. FIG. 11: Photograph by Thierry Le Mage © RMN-Grand-Palais / Art Resource, NY. FIG. 12: © Beaux-Arts de Paris. Dist. RMN-Grand-Palais / Art Resource, NY. FIG. 13: © Devonshire Collection, Chatsworth, reproduced by permission of the Chatsworth Settlement Trustees. FIG. 17: Erich Lessing / Art Resource, NY. Page 11: Scala / Art Resource, NY.